A BLUE DOG CHRISTMAS

BY GEORGE RODRIGUE

EDITED BY DAVID McANINCH

DESIGNED BY ALEXANDER ISLEY INC.

STEWART, TABORI & CHANG

NEW YORK

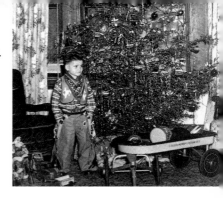

INTRODUCTION

In many ways, Blue Dog began as an artistic creation that would allow my art to embrace the present and future, but when I first sketched out these Blue Dog Christmas images, it was the past that came rushing into view—a veritable flood of holiday memories from my days growing up in New Iberia, Louisiana. Maybe it's just the nature of the season: Christmastime is filled with traditions carried on from parents to children to grandchildren, and memories are a natural ingredient of the holiday. Memories and legends—especially those of the Cajun people—have always played a strong role in my painting, but these Blue Dog pictures evoked recollections of a very personal nature.

The prints in this book may be filled with traditional symbols of the holiday season—a snowman, a Christmas tree, candy canes, toy soldiers—yet each picture is a window onto a very particular moment from my own boyhood, from a time when Christmas was still filled with mystery and a sense of pure joy. Putting Blue Dog in these Christmas settings has helped me retrieve some of that joy and mystery, which are so easily lost in the frantic rush of the modern-day holiday season. It also reminds me that the meaning of Christmas is inseparable from the magic of childhood, and that this magic doesn't necessarily have to disappear once you grow up.

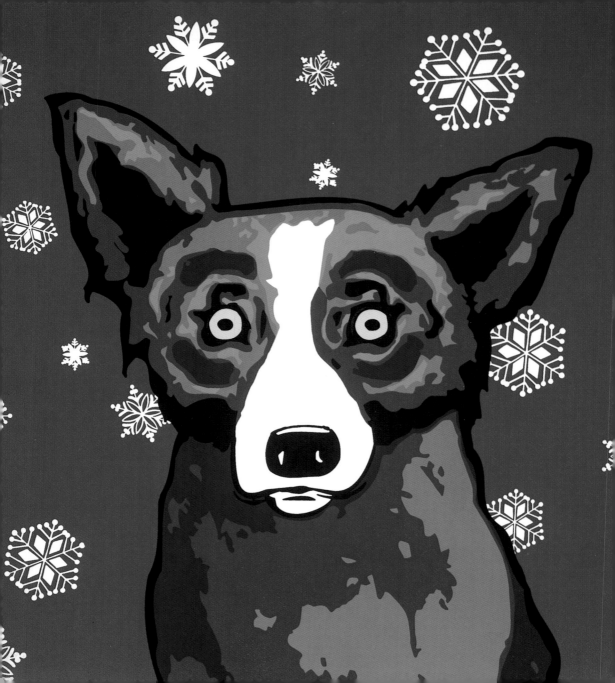

CHAPTER 1

Winter on St. Peter's Street

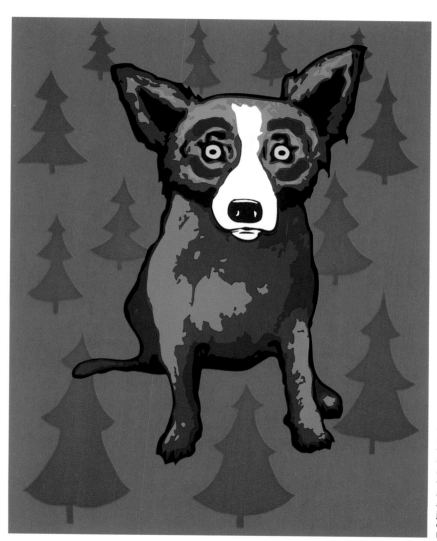

WRAP ME UP FOR CHRISTMAS
The crudely drawn wrapping-paper Christmas trees in the background are deliberately plain and uncomplicated, just as I would have drawn them when I was a child.

"The Queen City of the Teche." That's what they used to call my hometown. Originally a Spanish colonial settlement on the banks of the Bayou Teche, New Iberia was once a very busy place. Until the first part of the twentieth century, the best way to transport goods from New Orleans to the inland towns of Acadiana, or French Louisiana, was to send barges up the Mississippi River, across the Atchafalaya Basin, and into New Iberia's bustling port, which became the main unloading point for tons of goods, farm tools, and machinery. When the interstate came along, however, everything changed. The new superhighway ran straight through neighboring Lafayette, making it a much more convenient headquarters for businessmen during the offshore oil boom. The oil boom eventually

New Iberia was as magical a place as any during the Christmas season

subsided, but Lafayette has remained Acadiana's latter-day capital city.

Today, if you follow the Southern Pacific railroad tracks from New Orleans along the Old Spanish Trail into Iberia Parish, you'll come upon a quiet town, still surrounded by sugarcane fields and salt marshes, that looks virtually the same as it did when I was growing up. There is a faded but graceful downtown, the most famous feature of which is the stately Shadows-on-the-Teche plantation house, and a collection of modest one-story homes and small businesses. Near the end of

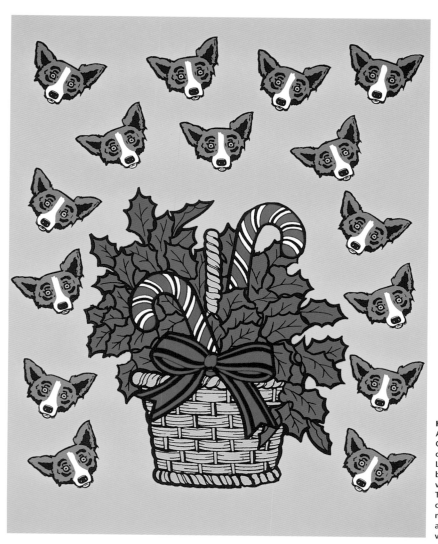

HIGH ON SUGAR
At the first sight of Christmas candy, my childhood dogs Lady and Trixie were beside themselves with excitement. This picture tries to capture that frantic moment—the dogs appear to be everywhere at once.

St. Peter's Street, a dead-end road that heads north out of town, stands the small brick house where I grew up.

New Iberia had perhaps lost some of its luster by the mid-1950s, when I was ten or eleven years old, but it was a fine place to a kid. In the mornings, I would walk a few hundred yards down the street to the Live Oak School, and then in the afternoons my friends and I would explore the woods and swamps that flanked our street, our dogs always chasing after us. And when I couldn't be outdoors, I was usually drawing or painting up in the attic, which my parents had helped me convert into a sort of art studio following my bout with polio in the third grade.

My town may not have had the bright lights and lavish store windows of New Orleans, but, in my mind at least, New Iberia was as magical a place as any during the Christmas season. The start of winter was always preceded by the sugarcane harvest, which is still a big event in Iberia Parish. And as fall turned to winter, you could sense a change in the air, with cooler winds blowing in from the north and west across the cleared cane fields as the lush colors of the bayou became more muted.

As the harvest festivals around the region drew to a close, folks in town began to gear up for Christmas. And for the devout Catholic community of New Iberia, gearing up meant going to church. Little surprise, then, that the main attraction in town was not a huge Christmas tree or arcades of brilliant holiday lights but rather a big nativity scene outside St. Peter's Church. The glass-enclosed manger

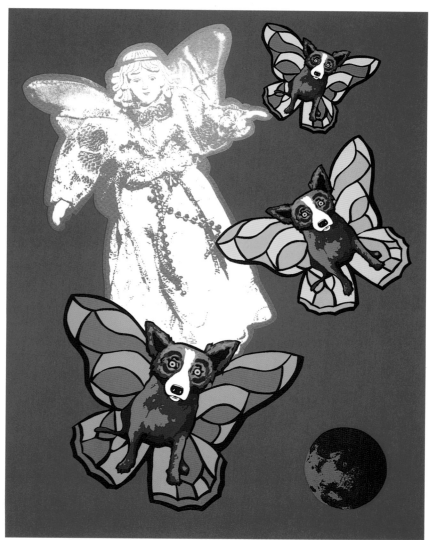

ANGEL BABY
Here, Blue Dog sails home for Christmas on the wings of an angel. The image of the angel in this print was taken from the ornament that once sat at the top of our Christmas tree.

was quite elaborate and included a real live mother and child; I can remember climbing in the car with my mom and dad to drive into town and see it. Most of my neighbors would do the same—just get in their cars and drive by slowly to behold the live manger scene.

Once or twice during my childhood, my family and I made the two-hour drive east to New Orleans to see the Christmas lights and admire the shop windows along Canal Street. Looking at all the toys and all the images of Santa and his elves, I couldn't help thinking of the lament of our local priest, who was fond of complaining about how commercial the season had become. Other nearby towns had their own way of welcoming the holidays, many of them with festive bonfires that would light up whole stretches of

This special holiday informed my early life as an artist

streams and rivers. In New Iberia, however, Christmas was mostly about church and family.

That's not to say there was any shortage of excitement on St. Peter's Street as December twenty-fifth approached. In fact, things often got pretty frantic as the big day got closer. Even now, I can recall feeling an overwhelming sense of mystery and anticipation. But to understand just how important Christmas was to me as a boy, just how much this special holiday informed my early life as an artist—and, of course, to understand how Blue Dog fits into it all—

*you first have
to meet a few central
characters from my
life during those years . . .*

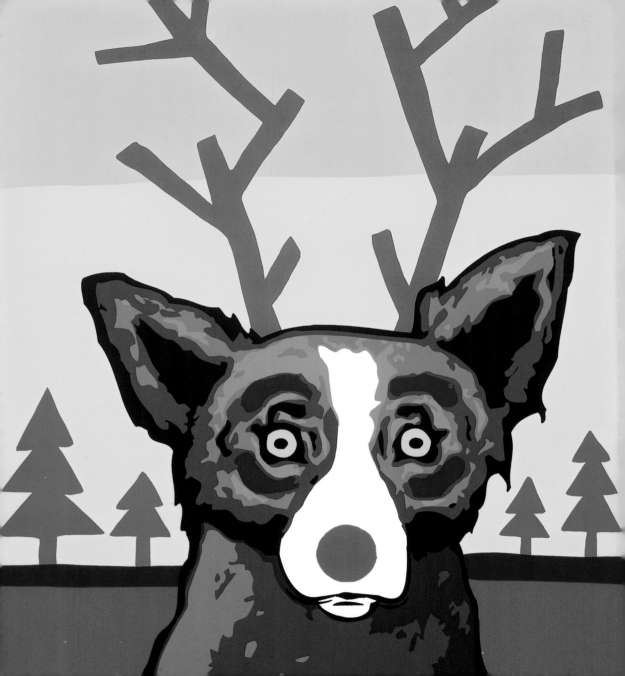

Dogs in the Manger

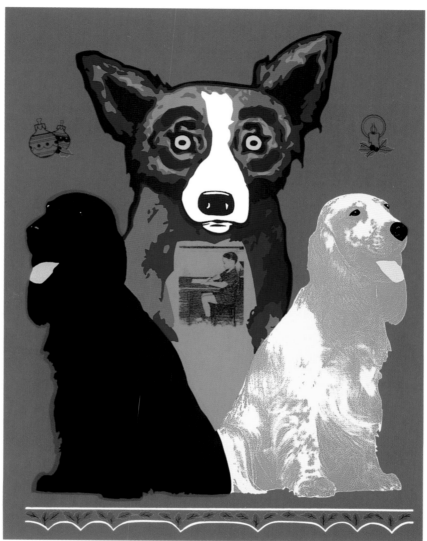

Previous page:

TRULY RUDY
One year, I went to great trouble to affix cardboard reindeer antlers to one of the dogs. The colors in the background may look like autumn hues to snowbound northerners, but, around here, this is what winter looks like most of the time.

GEORGE'S SWEET INSPIRATIONS
I've had three dogs in my life: Trixie, Lady, and Tiffany. Trixie and Lady met me every day as I came home from school, and Tiffany sat by my side for twelve years, watching me paint the Cajuns. Today, Blue Dog symbolizes many things, but at her heart is the spirit of these three animals, who loved me unconditionally.

It may sound strange, but when I think of Christmas, the first things that come to mind are not reindeer, mistletoe, Santa Claus, or even the story of the Nativity. No, when I think of Christmas, I think of dogs. In fact, I can't conjure a single boyhood memory of the holiday without the image of a dog appearing in my mind's eye. There were probably about twenty kids living on our end of St. Peter's Street when I was growing up, and virtually every one of them had a dog: there was my cousin's dog, Timothy; the neighbor's dog, Susie; another cousin's collie, who answered to Bobby—I can remember all their names (the dogs', that is, not the owners'). And then there were two floppy-eared terrier-spaniels named Lady and Trixie.

Lady and Trixie were special—

Lady and Trixie were special— more like siblings, in fact, than pets

more like siblings, in fact, than pets. I was an only child, and these two dogs were my constant companions; they participated in almost everything I did, especially around Christmastime. Trixie came first; she was a black terrier-spaniel mix. Unlike Blue Dog, however, Trixie had inherited the floppy ears of a spaniel, not the pointy ones of a terrier. When Trixie had her second litter, I pleaded with my parents to allow me to keep just one of the puppies—the lone white one. "You don't need another dog, George," was their response. "But Trixie needs a friend," was mine. My logic, or,

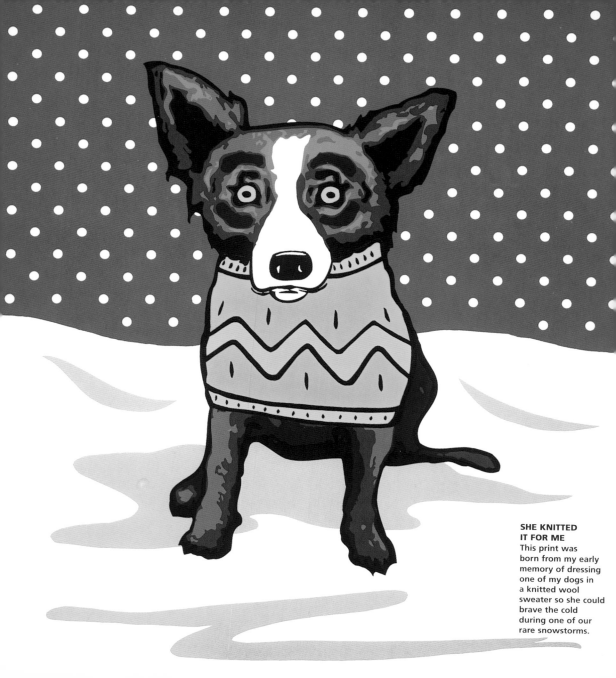

**SHE KNITTED
IT FOR ME**
This print was
born from my early
memory of dressing
one of my dogs in
a knitted wool
sweater so she could
brave the cold
during one of our
rare snowstorms.

more likely, my persistence, won the day, and so Lady joined the family.

A few years later—it must have been the winter of 1957 or 1958—we got a heavy snowfall and enough of a cold snap to keep the white stuff on the ground for a few days, which was very unusual for Louisiana's Gulf region. All the kids on St. Peter's Street poured out of their houses, dogs in tow, to build snowmen. It was an unforgettable scene—the first time most of us had seen thick snow on the ground. The excitement was contagious, and I can remember the whole street ringing with the sounds of shouting kids and barking,

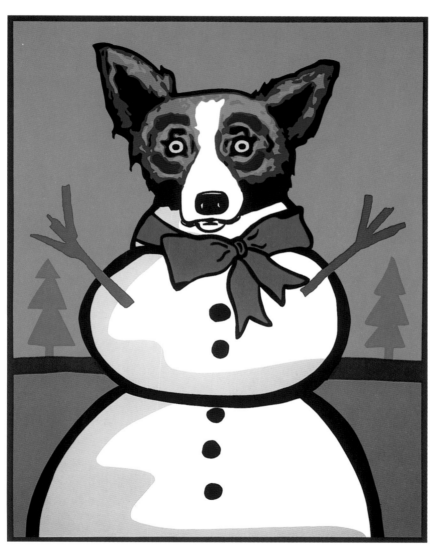

FROSTY
It hardly ever snows here in South Louisiana. The sight of one little flake sets off giddy pandemonium: schools close; the airport shuts down; and we all pray that it sticks. It's not unusual to see a "snowman" made of packed mud and coated in the frost we wishfully call snow.

scampering dogs. Indeed, as the Christmas holiday approached, Lady and Trixie could sense a different type of energy around the house. They would sniff eagerly around the ever-higher stacks of packages and decorations, knowing something big was going on.

I was scarcely less excited. During those early years, Santa was still very real, and I will never forget the sense of awe that would wash over me when I first laid eyes on all the presents spread out before me in our living room, which seemed to be literally bursting with toys. There were cowboy boots, toy guns, hats, fire trucks—typical stuff for a little kid at the time. But the one moment that shines brightest in my memory was the day I received an erector set, the one thing I had been pining for more than

During those early years, Santa was still very real

anything else. There it was under the tree, beautifully and lovingly assembled by my father (who insisted that it was Santa who had gone to the trouble of putting it together). I played with that set for a good ten years after that.

The presents weren't all for me, however. I quickly made it clear to my parents that Santa had to pay a visit to Lady and Trixie as well, and, sure enough, each of their stockings was soon stuffed with dog toys and cans of food. There was more dog food around our house at Christmastime than there were candy and cakes, in fact.

But the dogs
weren't just passive
participants
in the holiday.

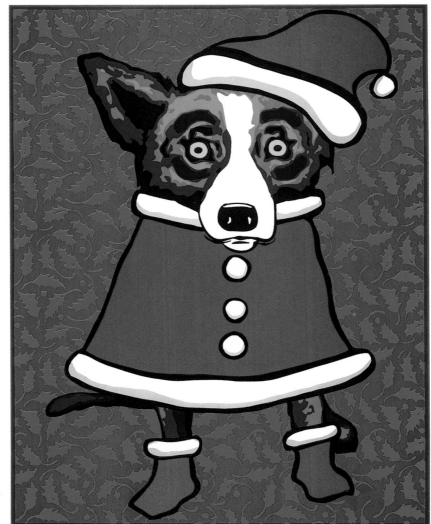

SANTA'S HELPER
The most unlikely characters make great Santas. At one recent Christmas party, our friend Dickie Hebert volunteered his services, and even though he's skinny and balding, he still managed to convince the kids. From then on, we agreed that Dickie's the only Santa for us.

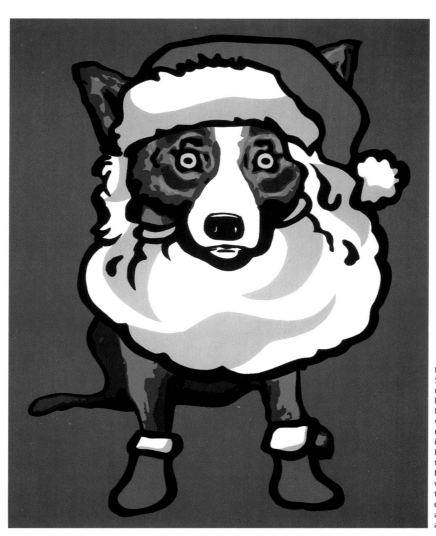

HO HO HO
Santa Claus may not have had a huge presence in New Iberia, a town where you were more likely to see images of the Holy Family on the street than you were Saint Nick. And yet Santa was always an essential part of the holiday for me—almost as important as Lady and Trixie.

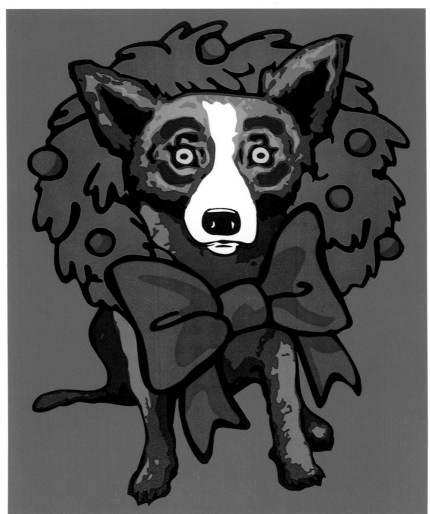

EVERGREEN JOY
My dogs were my pride and joy when I was young, and what better way to honor them than to place big Christmas wreaths around their necks?

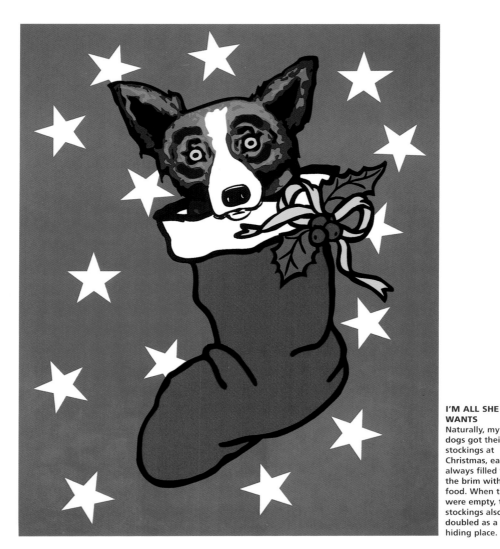

I'M ALL SHE WANTS
Naturally, my dogs got their own stockings at Christmas, each one always filled to the brim with dog food. When they were empty, the stockings also doubled as a cozy hiding place.

With my help, they'd be decked out in holly, bows, and sometimes Santa hats and coats. They would sit patiently as I purposefully attempted to attach cardboard reindeer antlers to their heads, or place them in gift baskets and dress them in wool ski sweaters. Willingly or not, Lady and Trixie became my mobile holiday art projects.

As I grew a little older, however, this artistic urge began to require a broader canvas. I must have been in the fifth or sixth grade when I first had a real sense that I wanted to be an artist. I could see that I was the best drawer and painter in my class, and, to be honest, I realized that creating art projects was a great way to show off. So when Christmas rolled around, I began to think of it as the perfect opportunity to put my skills to work, and I knew that I had to set my sights on something bigger than turning Trixie into a reindeer. You could safely say that Christmas was the occasion for my first public exposure as an artist; it offered the first opportunity for me to develop a feel for color, form, and design. The holiday began to have less to do with getting presents and more to do with cutting, pasting, sawing, nailing, and painting.

It will probably come as no surprise that the first big Christmas piece I did was a manger scene. My initial goal was simply to outdo the Nativity scene at our local school by building a more lavish one at home. I remember constructing the whole thing with rocks, straw, bushes, sand—everything but a live baby Jesus. That first year, my "installation" attracted the attention of some of the neighbors and earned me some hearty praise from cousins

and other relatives who came around to visit during the holidays. But no one appreciated my manger scene more than Lady and Trixie and the neighborhood dogs, who quickly found a cozy spot in the hay that filled my giant diorama and were content to nuzzle up with the Holy Family and the Wise Men.

The following year, when I heard that the town of New Iberia was sponsoring a contest for best-decorated house during the holidays, I was determined to create something really spectacular. I was in my early teens by then and was old enough to climb ladders and pound nails, so I set about making a gigantic Santa Claus in front of our house. I spent a good chunk of money at the local lumberyard and on lights to illuminate the whole thing. I created giant painted-cardboard presents to put at Santa's feet, and I ended up having to change the configuration of my whole house to accommodate the huge effigy. Lady and Trixie, as well as my parents, could do little more than sit by and watch. When I finally finished, you could see my Santa from a block away, and the city saw fit to award me the second prize: twenty dollars, not quite enough to cover the cost of making the thing in the first place (my mother, flabbergasted that I didn't come in first, protested that the contest was fixed).

In the two or three years that followed, I continued to enter the local Christmas decorating competition, and I always managed to come away with a prize. My real goal each successive year was to outdo what I had done the year before. It was my first experience with one of the fundamental challenges of being an artist—the challenge of

constantly having to create something new, something better than before. Sure, I enjoyed the compliments I'd get from cousins and neighbors each year, and I did think of my decorations as a sort of gift to my family and to the town. But, more than anything, these Christmas projects were a gift to myself, and as the thrill of believing in Santa and getting presents began to fade, a finer sensation took its place: the pure, transcendent joy of creation, of making art. This gradually grew to be the very core of Christmas for me.

Still, after four or five Christmas seasons, I think I started to get a little tired of making these huge projects, despite the joy and praise they brought me. Creating all these elaborate yuletide decorations had set off a spark; it had unleashed my passion for art, and soon this passion would be too big to contain within the confines of my small hometown, much less our little brick house on St. Peter's Street. As it was for many of my friends, who would soon have to leave school and find work, childhood was drawing to a close for me, even though I may not have been aware of it at the time.

In the years leading up to my leaving New Iberia, Lady and Trixie remained by my side almost ceaselessly, and their presence at Christmastime continued to be a constant source of joy and inspiration. At the time, I really had no idea that the world I grew up in would deeply inform the nature of my paintings in the decades to come. And it would be years before I could recognize that Lady and Trixie had planted the seeds for Blue Dog, a creation that would, years later, help me retrieve the magic of Christmas.

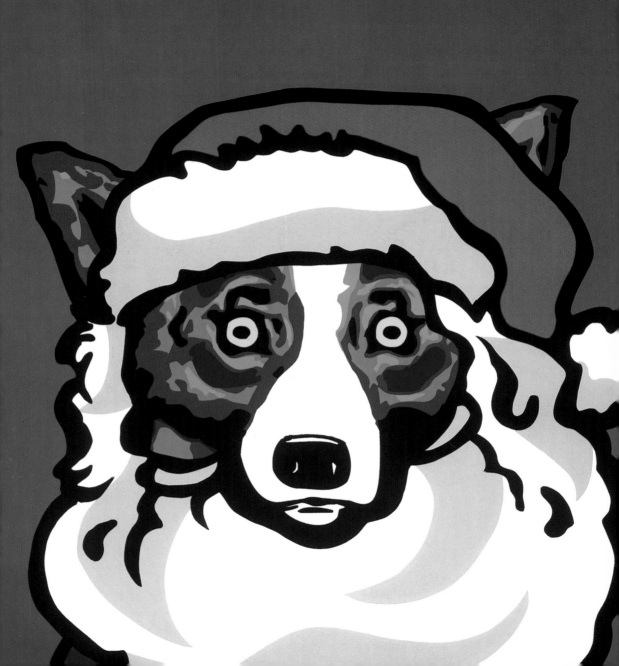

Blue Dog Joy

Christmastime often brought with it a familiar sense of longing.

Not long before I left New Iberia to go to art school in California, Trixie passed away, and, just a few months later, Lady followed. I'm sure Lady died of a broken heart—she wouldn't even come into the house after Trixie was gone. With their passing, I felt a chapter in my life come to a close, and moving away seemed a natural thing to do. Christmas was different from then on. When I came home for the holidays, things were quieter around the house; there was still happiness in seeing my family and friends, but much of the joy and mystery of the season seemed to have disappeared.

By the time I finally made the decision to move back to South Louisiana after art school and a stint in the army, I missed Lady and Trixie so much that I decided to get yet another terrier-spaniel—

this one was black-and-white with pointy ears—to keep me company in my studio as I painted the people and landscapes of Acadiana and raised a family of my own. I named my new companion Tiffany.

Tiffany was a lively presence in my home. And yet Christmastime, even with my own children filling the house with noise and excitement, often brought with it a familiar sense of longing. In the end, I figured that you simply couldn't keep the enchantment of Christmas alive forever. After all, even with kids and pets around to keep things fun, it's still the adult who has to buy the presents, pick up

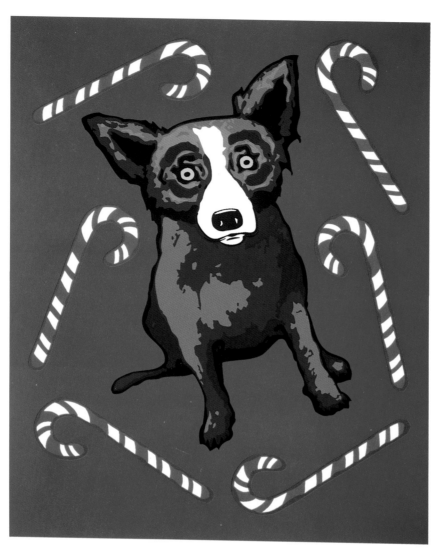

SWEET LIKE YOU
My mother, at the age of ninety-five, still has her sweet tooth—well, at least a couple. Believe it or not, she's worn false teeth since she was sixteen years old, when the dentist yanked out almost all her natural ones. For years, she's eaten all the chocolate-covered cherries and candy canes her stomach can handle.

the shredded wrapping paper and bows, make sure the dog doesn't chew through the Christmas tree lights, and do scores of other tasks that Santa tends to get credit for. Sure, my kids were having a fine time during Christmas, but I wanted to know how I could get that feeling back for myself.

The fact of the matter was that I wasn't a kid anymore; I was a professional painter with work to do and a family to take care of. I wasn't sure when it had happened, but somewhere along the way I had grown up. Maybe it had all started many years before, when I was rummaging in a closet a few weeks after Christmas and found a present my mother had forgotten to wrap. When I showed it to her, she blushed and stammered some excuse about how Santa sometimes leaves "secret" gifts for kids to find, but I got the drift. Or maybe it was a few years after that, when I was in my teens and decided that I was getting too old to make Christmas decorations and that I had to become a "real" artist. Whatever the explanation, I had to face it: Christmas is a kids' holiday. Maybe grownups should just be content with their memories and move on.

In fact, that's what Christmas seemed to be all about: memories and tradition. While other images of my childhood were fading, my recollections of Christmases past, no matter how distant, were as clear as ever. I could remember the most minute details about a particular Christmas Eve many years before, just as I could recall every detail about that old erector set. And the traditions I grew up with were the very same ones I wanted to pass on to my own kids—

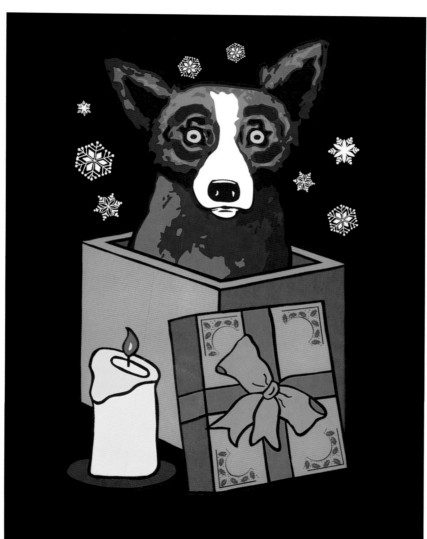

MIDNIGHT SURPRISE
Though my mother protested, my dogs were allowed to play inside the house around Christmastime. Sometimes, when we returned from midnight Mass on Christmas Eve, the dogs had gotten a jump on opening the presents.

whether it was the tried-and-true rituals like decorating the tree or less common ones like, say, dressing my dog up as Santa Claus.

If anything, though, Christmas started to make me feel older, not younger. I began to understand that Christmas is as much about change as it is about continuity. I noticed that babies and children had grown since the previous year; teenagers started to seem a little more like adults; young adults soon became mothers and fathers; and moms and dads became grandparents. My sense of time's passing became more pronounced, and the faces at the Christmas dinner table looked a little different each year. My own children were growing up, and the toys around the Christmas tree were getting bigger, noisier, and flashier. It's no wonder we retain such vivid memories of the holiday, I thought, because these memories allow us to hang on to a past that we feel might be slipping away.

All these ideas were bouncing around in my mind as I tried to figure out exactly what it was that could fill the empty space I felt around Christmastime. With Tiffany by my side, I continued to work in my studio, painting the scenes of Cajun life upon which I had built my reputation as an artist. And yet the more involved I got in painting these images of fading Cajun traditions, the more distant I felt from the carefree days of my childhood, and particularly from those pure, uncomplicated feelings of happiness I felt at Christmas. The need for a change in my life kept gnawing at me. Then, as always seems to be the case, change did come, quite unexpectedly:

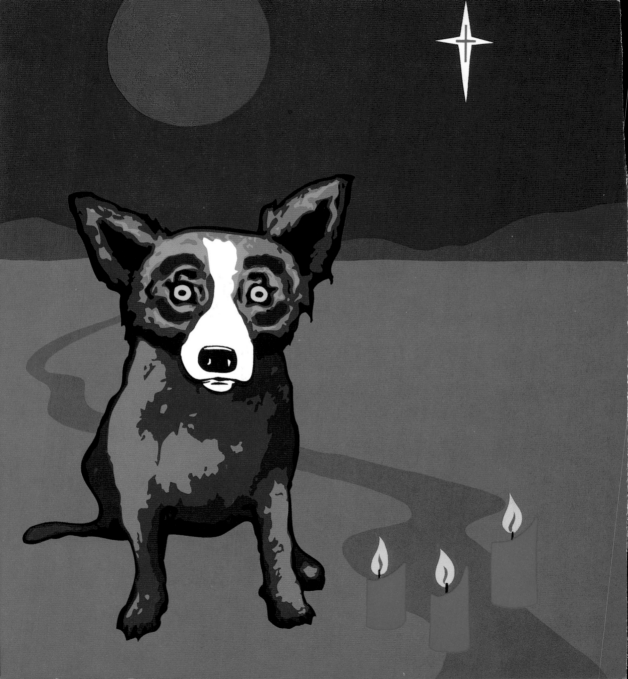

Tiffany passed away.

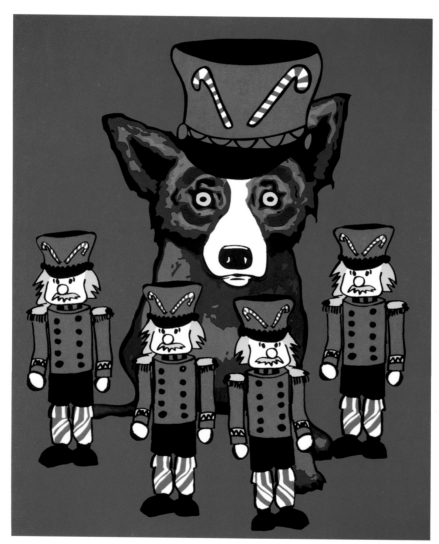

Previous page:

SILENT NIGHT
Many years of going to church when I was a boy have forever imprinted the biblical story of Christmas in my mind. Here, the three candles represent the three Wise Men led by the Star of Bethlehem.

SOLDIER BOY
I had toy soldiers like these as a child, and this picture is a particularly poignant reminder of my childhood. As always, the dog is present, my sole companion.

Just as the deaths of Lady and Trixie had marked the end of a chapter of my life, the sudden absence of Tiffany seemed to announce the beginning of a new one. Born from her memory was a new creation: Blue Dog, a strange, sad-eyed figure who began to appear in almost all my paintings—at first in somber bayou landscapes but later in more colorful, playful settings. I could feel myself becoming less and less concerned with the past and more interested in the present, and I began to paint with a renewed energy and a keener appreciation of the things around me. Blue Dog quickly became the central character of my imagination, and of my professional life as a painter.

I'm not sure when I first got the idea to try and put Blue Dog and Christmas together; at some point I

Blue Dog quickly became the central character of my imagination

guess I just had a hunch that Blue Dog might be the key to unlocking those feelings of joy I used to feel at Christmas. There was really no reason to believe otherwise: no matter how I painted her, Blue Dog seemed to fit in everywhere, without regard to the boundaries of time and place. If Blue Dog could help free me from the memories of Tiffany, why couldn't she help reunite me with feelings from an even more distant past?

So I got started, and before long, I felt like I was back on St. Peter's Street. There, before me in my studio, were the toy soldiers, the baskets of candy, the snowmen—

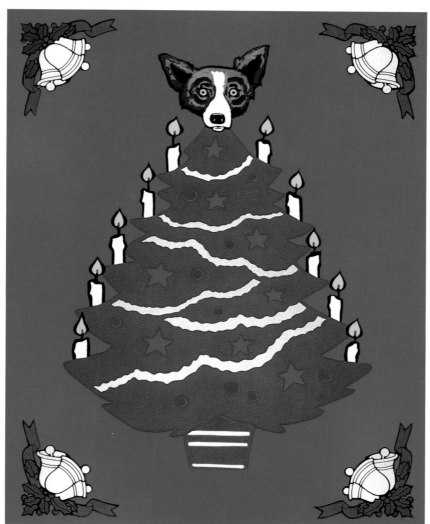

TREE TOPPER
Having my dogs running around while we trimmed the tree may not have made the process any easier—on more than one occasion they knocked the whole thing down—but I never thought of doing it without them.

and, most wonderful of all, Lady and Trixie. The many years that separated me from those images seemed to melt away, and as I completed one picture and moved on to another, the presence of Lady and Trixie grew stronger. The joy they used to bring to Christmas at our house became real again. Even though Lady and Trixie weren't physically by my side, barking their approval, they were very close by: I could feel them looking back at me mischievously through Blue Dog's eyes as if to say, "We've been here all along, George. All you have to do is look." For the first time in what seemed like ages, I was looking at my art, and at Christmas, through the eyes of a child.

This, I realized, is one of the greatest joys of the Christmas season—the fact that it brings out the child in everyone, regardless of age. At the heart of the holiday is the story of a birth, of the magical beginning of life. And, once a year, we are given an occasion to feel this magic anew, and to remember that the potential for rebirth is always within us. Sometimes, we just need a little help; we need someone or something, like Blue Dog, to come along and coax the little kid inside us out of hiding. Blue Dog taught me that I didn't have to cling to the past in order to enjoy Christmas; the past was always alive and well inside me. Once I realized that, everything seemed to bristle with a new energy, and Christmas once again became infused with enchantment, and with the feeling that for one special day the normal goings-on of life can cease so that every heart—in adults and children alike—

can be filled with Joy.

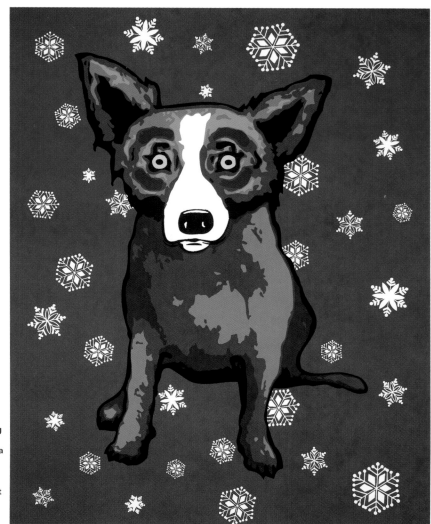

**SHE LEFT ME
IN THE COLD**
In other paintings,
I've rendered falling
snow as simple
white dots against a
blue background,
in a sort of Pop-art
manner. Here, I
wanted to highlight
the true, natural
intricacy of the
snowflake.

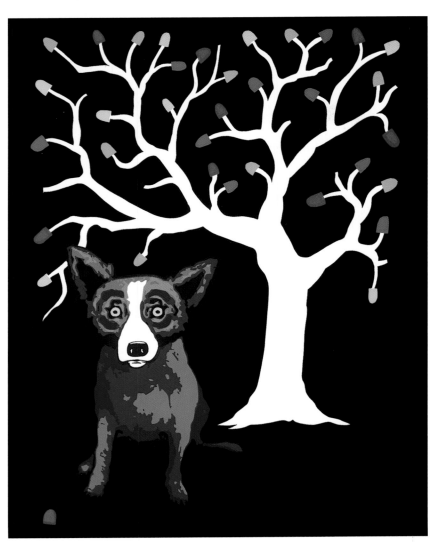

SWEET PICKIN'S
My mom used
to pull up a sticker
bush, paint the
whole thing white,
and put gumdrops
on the end of each
thorn. We'd pick the
gumdrops right off;
there were enough
to last for days.

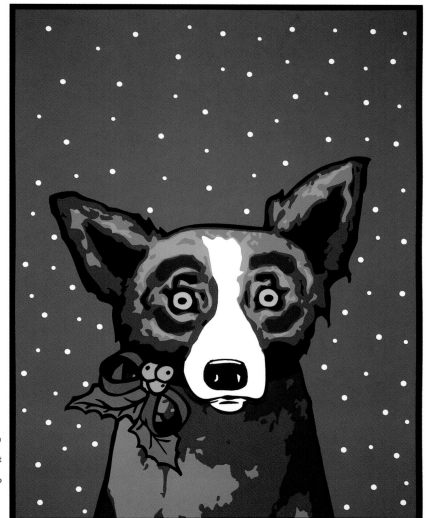

PAPER, RIBBONS, AND ME
Some people deck their houses, their front doors, or even their cars with boughs of holly, but when I was a kid it seemed natural to decorate my dogs. Lady and Trixie never seemed to mind a bit.

All artwork is from George Rodrigue's Christmas Blue
Dog Series. Each 10-color hand-pulled silkscreen print has
been published in a limited edition of 150, measuring
20 x 16 inches. The series was printed between 1998 and
2000 by Thom Barlow at Screen Porch Printers in
Ponchatoula, Louisiana.

Project editor: Sandra Gilbert
Production: Kim Tyner

Published in 2000 by Stewart, Tabori & Chang
A division of U.S. Media Holdings, Inc.
115 West 18th Street
New York, NY 10011

Distributed in Canada by
General Publishing Company, Ltd.
30 Lesmill Road
Don Mills, Ontario, Canada M3B 2T6

Library of Congress
Cataloging-in-Publication Data
Rodrigue, George.
A Blue Dog Christmas / George Rodrigue ; edited by
David Mcaninch ; designed by Alexander Isley Inc.
p. cm.
ISBN 1-58479-020-2
1. Rodrigue, George. 2. Artists—Louisiana—Biography. 3.
Prints—20th century—United States. 4. Christmas in art.
5. Dogs in art. 6. Tiffany (Dog) in art. I. Mcaninch, David.
II. Title.

NE539.R547 A2 2000
394.2663—dc21
 00-041299

Design by Alexander Isley Inc.

Printed and bound by
Toppan Printing Company, (Hong Kong) Ltd.

1 3 5 7 9 10 8 6 4 2
First Printing